G000116053

# HOW TO USE THIS BOOK

It is helpful to study the various parts of a flower before making a drawing of it. From the leaves to the stem and the petals, to the center of the flower, each one has its own unique shape and texture. On some you will notice the stamens and pistils first, and on others the centers are less visible, depending on the angle of the flower and the stage of blooming. This book provides you with step-by-step instructions for drawing your own garden flowers. When using the instructional pages, note that the blue lines show you what to draw in each step. There is also a completed black-and-white, full page line drawing of each flower for you to use to experiment with different media and color techniques. When you are ready to begin drawing your own flowers, turn to the back of the book, where you will find eloquently bordered practice pages. The practice pages are perforated for easy removal and display.

Despite their detailed appearance, most flowers have basic repeating shapes that make them fairly easy to draw. Take notice of each flower's basic shape, angle, and the number of petals it has. Take your time creating the initial shapes. There are veins on the leaves, and different ways they connect to the stem, all of which can add interest to your composition. Even a single flower is worthy of a good study. You can shade your drawing with pencil or graphite, or color it in with colored pencil, pastels, markers, or paints. Before you begin, you may wish to experiment with both soft and hard lead pencils on a piece of scrap paper to find what suits your taste.

# BLEEDING HEART

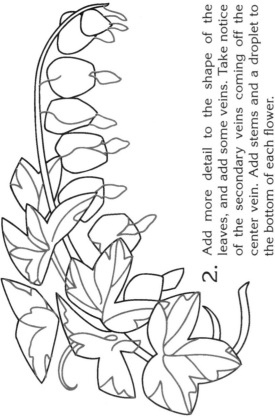

1. Outline the six leaf shapes. Add the stem which starts under the leaves, and curves upward and to the right. Draw in eight shapes for the flowers, with the smallest shape positioned at the tip of the stem.

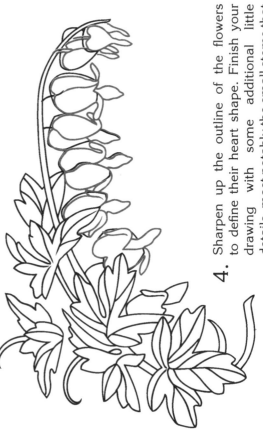

2. Add more detail to the shape of the leaves, and add some veins. Take notice of the secondary veins coming off the center vein. Add stems and a droplet to the bottom of each flower.

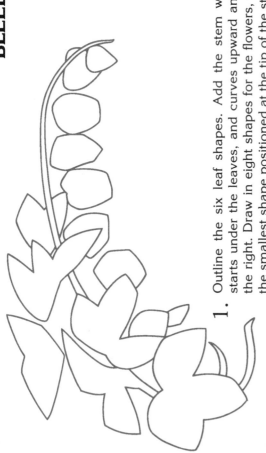

3. Refine the outlines and add some additional veins to the leaves. Add some outlining to the flowers.

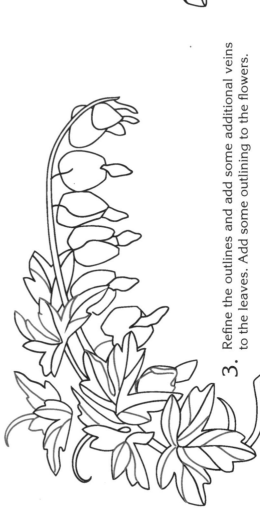

4. Sharpen up the outline of the flowers to define their heart shape. Finish your drawing with some additional little details, most notably the small stems that connect the main stem and the flowers, as shown on the next page.

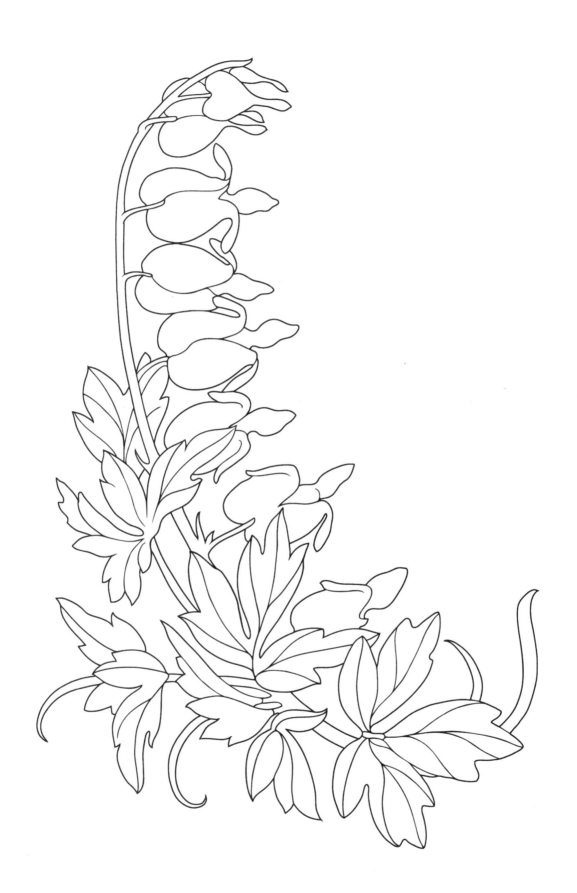

# CAMELLIA

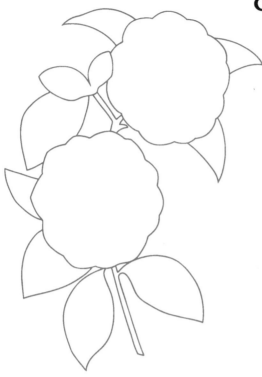

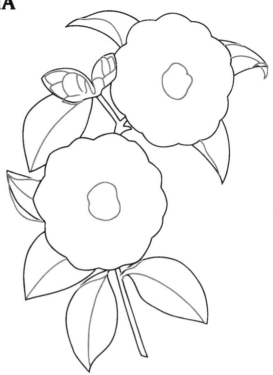

1. Draw two circular shapes with scalloped edges. Add the stem and leaf shapes that grow from under each blossom and attach the leaf shapes to the stem. Add ovals for the budding flower shapes; these should slightly overlap with the flowers.

2. Draw a small circular shape in the center of each flower, and add a curving line to each leaf. The lines on the top leaves should be off center due to the angles they are sitting at. Add some detail to the buds.

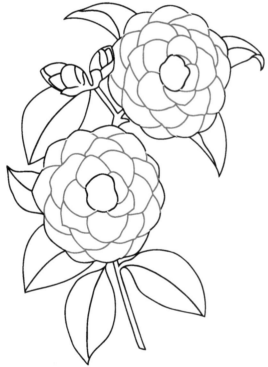

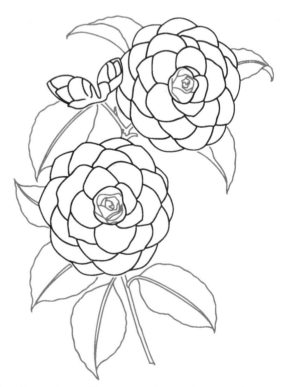

3. Draw the rest of the flower petals. They overlap each other from the center outward, and resemble the pattern of fish scales.

4. Accentuate the curvy lines of the leaf edges and add a second line to the veins on the larger leaves. Add a little detail on the stem area between the flowers, and some small petal lines on the center of the flower. Finish your drawing with some additional shaping of the petals and flower buds.

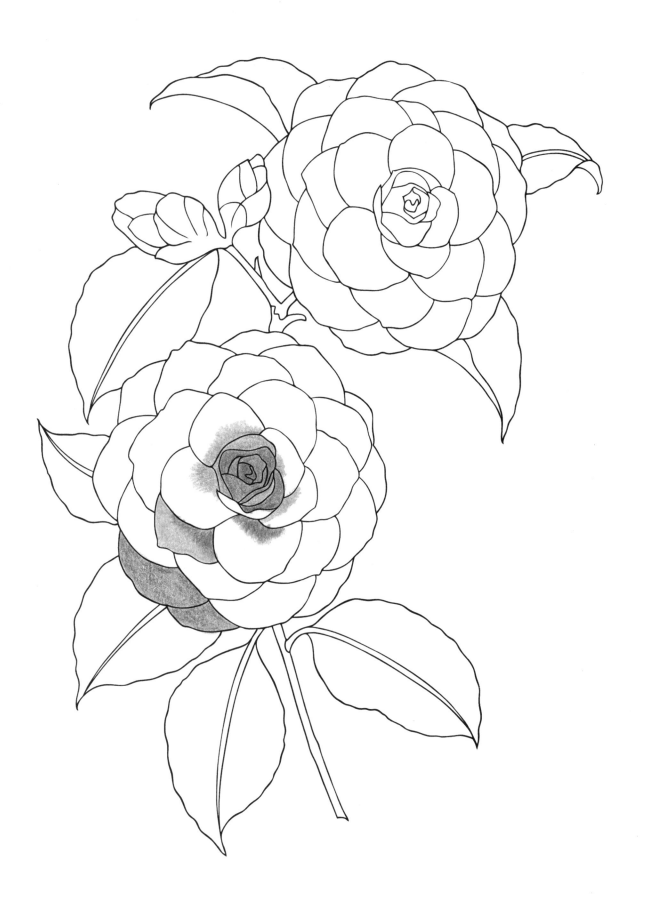

# CONEFLOWER

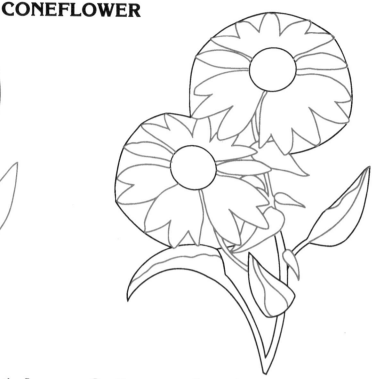

1. Draw two overlapping rounded shapes for the flowers, and add a smaller circle to the center of each. Draw a curving stem, and the outlines for the leaves, branching out from the main stem.

2. Draw an outline indicating the position of the petals. The point of each petal should touch the edge of the larger circles. Add lines to define the edges of the leaves, and their central veins.

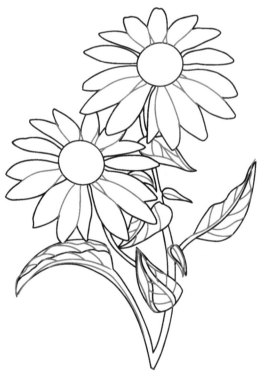

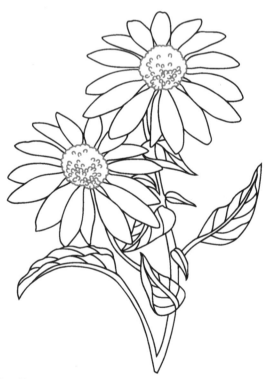

3. Add more veins to each leaf. These should follow the contours of the direction the leaves are growing. Add lines to separate the flower petals and connect them to the center.

4. Draw some small shapes in the center circle to suggest the spines that grow there. Finish your drawing with some additional shaping of the petals and leaves. Add a little curved notch at the tip of some of the petals, as shown on the next page.

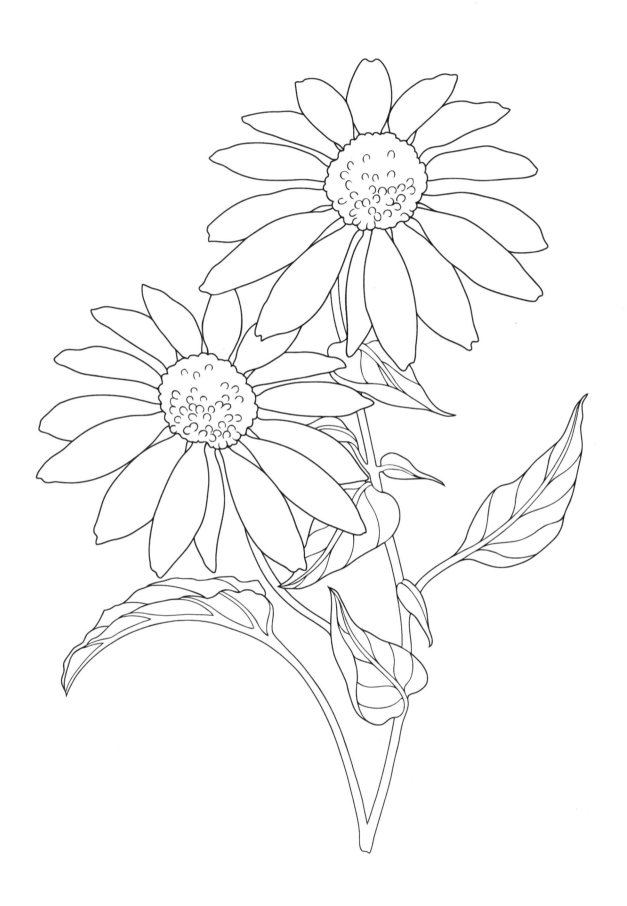

# DAFFODILS

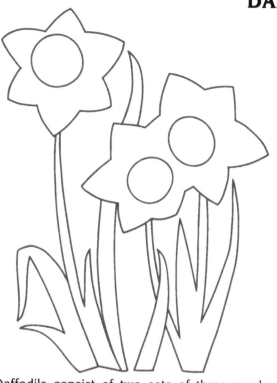

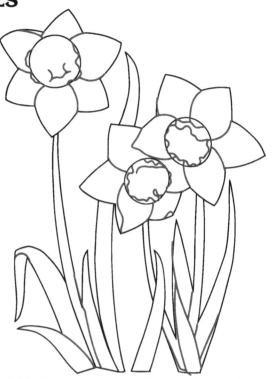

1. Daffodils consist of two sets of three overlapping petals. Start with a wide, six pointed star shape, and add a large circle in the center. Draw in the general shape of the leaves and stems.

2. Add lines connecting the petals to the center circle. Add some curvy lines to the center shape, forming the rim of the "cup". Add lines to separate the leaves and stems.

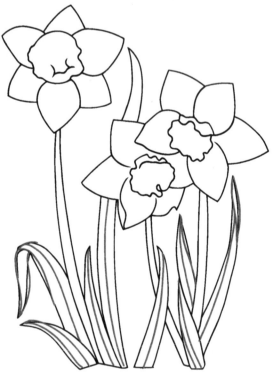

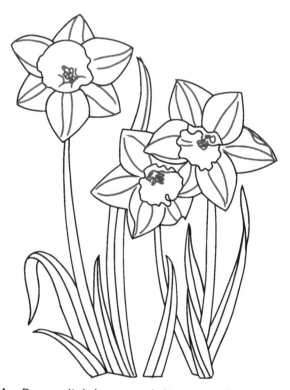

3. Draw lines up the center of each leaf for the veins.

4. Draw slightly curved lines on the petals, to indicate the shape and texture of the flowers. Add details to the center of the cup. Finish up by refining the line work on the flowers, as shown on the next page.

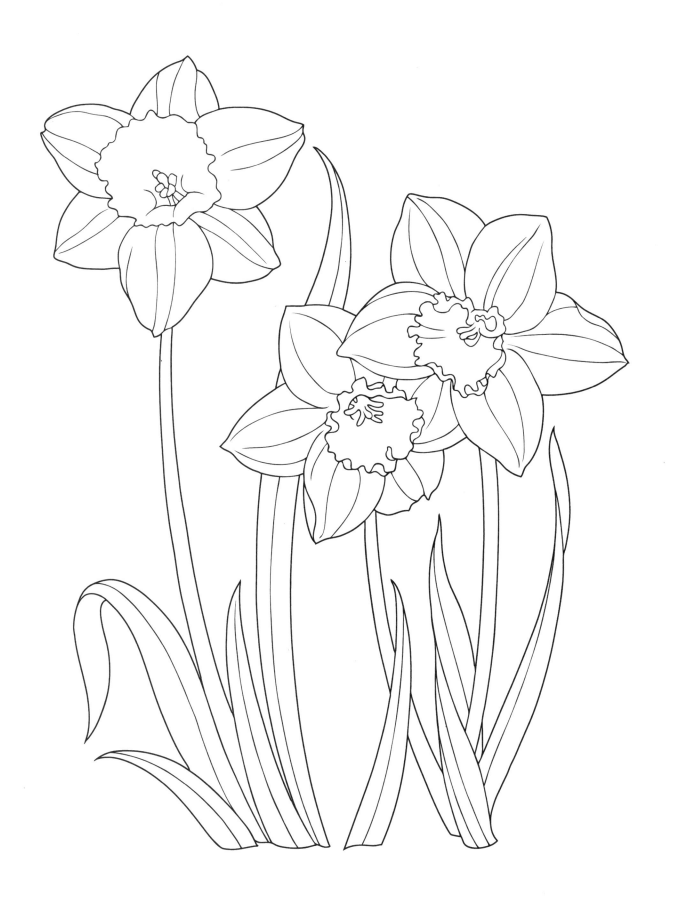

# DAHLIA

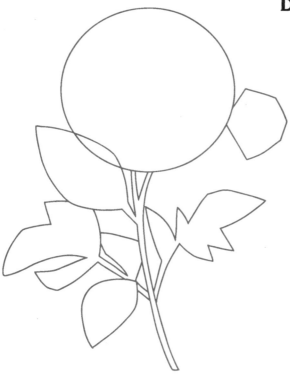 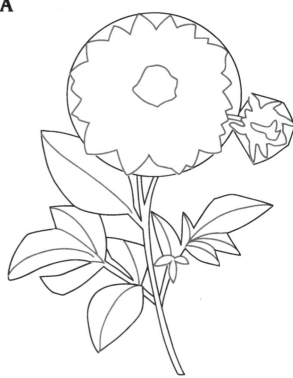

1. Draw a circle, indicating the outer edges of the flower. Add a small shape to the right side for the bud. Draw a curving stem, and add the outlines of the leaf shapes, attaching them to the stem.

2. Draw the edges of the flower petals inside the circular shape. They can overlap a bit at the bottom. Draw the outer shape of the bud about to open. Add some veins to the leaves, and add a smaller budding leaf on the right.

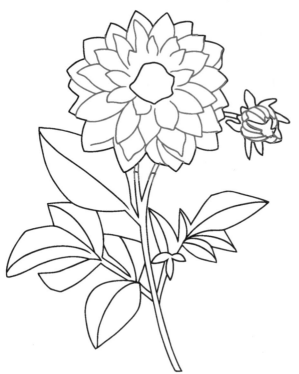 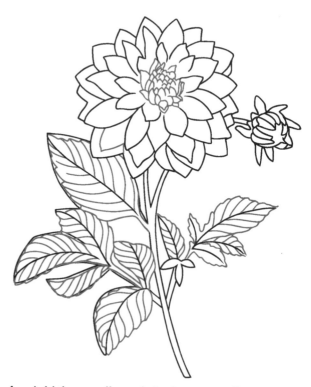

3. Draw the flower petals. They overlap from the center outward as on the camellia, and are smaller toward the middle. Add some petal detail to the bud, and finish drawing in the top of the stem.

4. Add the small petals in the center. Draw a number of veins on each leaf, curving the lines to give the leaf its shape. Define the leaf edges. Finish up by refining the line work on the flowers, and adding the lines that connect the smaller stems to the main stem, as shown on the next page.

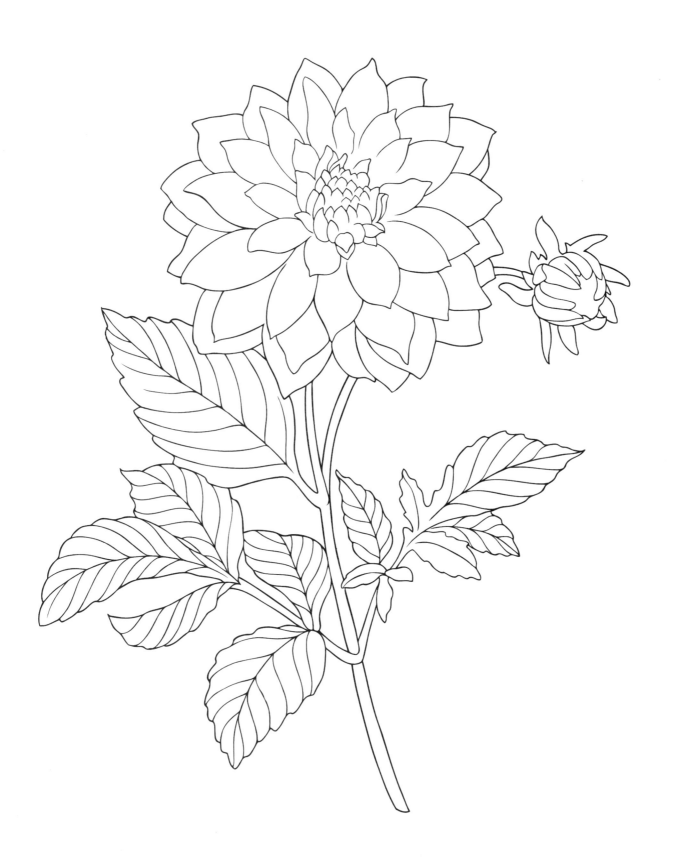

# DAY LILY

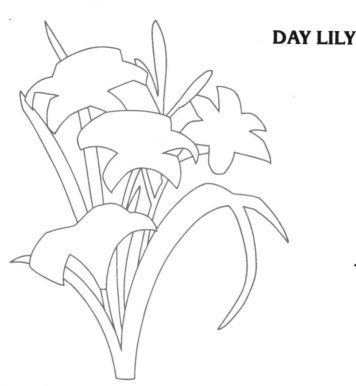

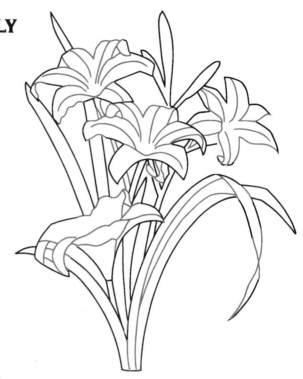

1. Draw the basic shapes of the flowers, three at the top and one below. Add the stems and curved lines to outline the leaves. The leaves grow up and out to the sides. Add oval outlines for the buds at the top.

2. Day lilies have six evenly spaced petals (if viewed from above). Define the flower shape more with additional lines. Add lines that start near the centers and curve out to the tips of the petals. Add a few lines to the leaves.

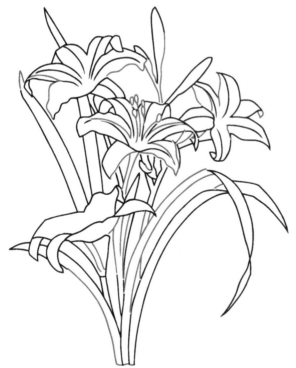

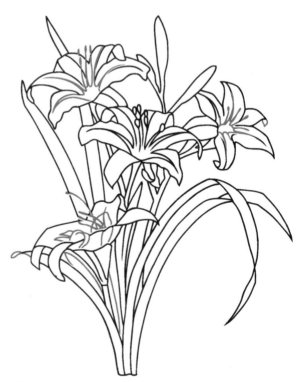

3. Add stamen and pistils to the middle of the center flower. Define the stems where they attach to the flowers and leaves. Add more detail to the edges of the flower.

4. Draw stamens and pistils in the centers of the other three flowers. Add detail to the lower flower, and more lines to the lower leaves. Finish up by refining the line work on the flowers, paying particular attention to the centers and the veins that lead into them. Make sure you have drawn in the lines on the petals that show the underside at the tips.

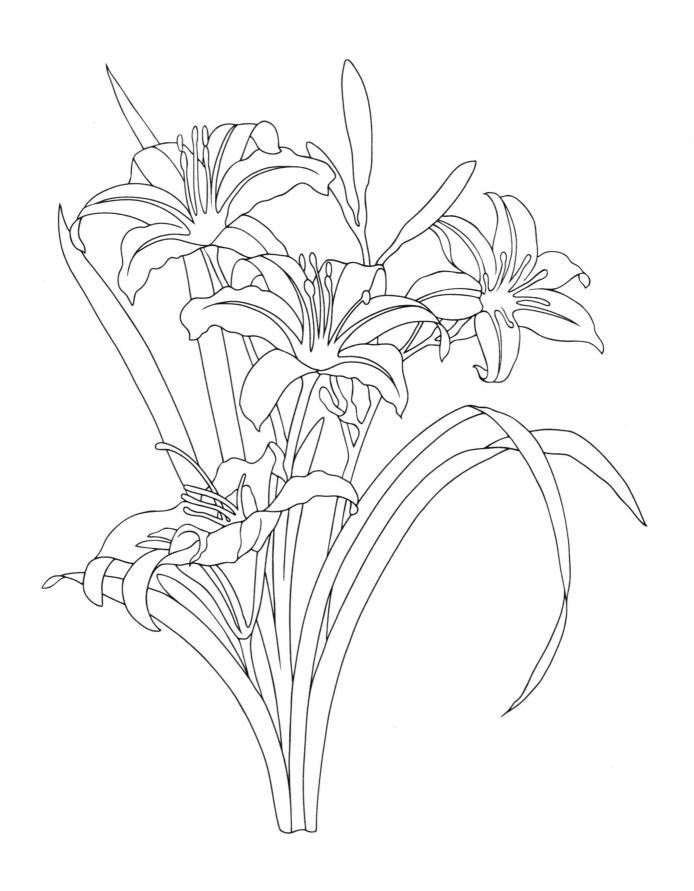

# DELPHINIUM

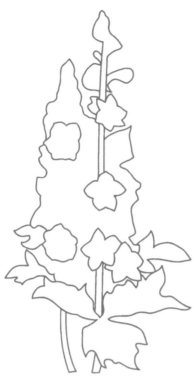

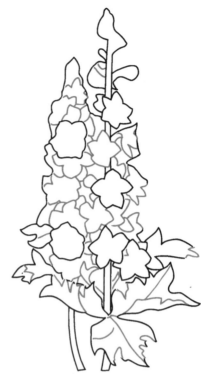

1. The delphinium consists of many small florets attached to a main stem. Draw portions of the stem and a few outlines for the flower shapes. Create an outer shape to indicate the outer edge of the rest of the florets. Draw in the general shape of the leaves.

2. Add more florets in the defined space, and add some veins and other detail to the leaves. Draw several indentations along the leaf edges to give them shape.

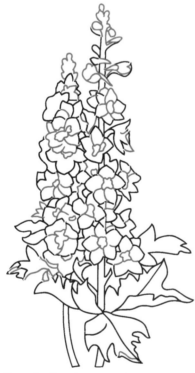

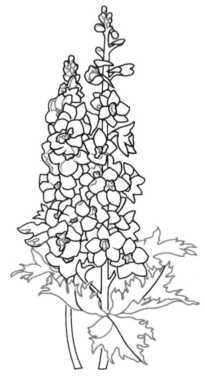

3. Draw lines indicating petals, and add some center detail to the florets. Draw some small, rounded buds at the top of the stem, including the spurs that are visible.

4. Add more detail to the floret centers and the top of the stems. Define the edges of the deeply lobed and toothed leaves. Finish your drawing by adding more detail to the overlapping florets.

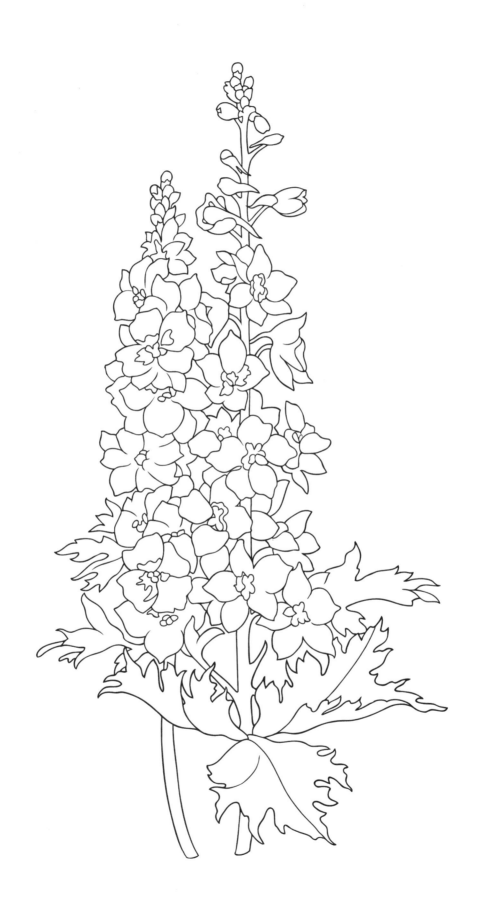

# GLADIOLUS

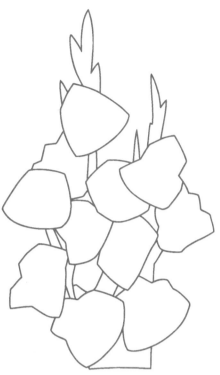

1. Draw eleven overlapping shapes for the flowers. Behind these add lines suggesting narrow, sword-shaped leaves reaching straight up, and a square-shaped base at the bottom.

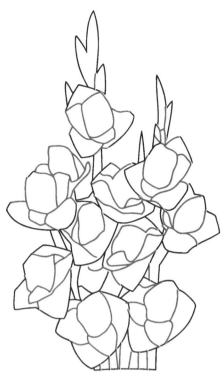

2. Draw lines within the flower shapes to indicate petals. Note that gladiolus petals are not in a typical arrangement. Draw some vertical lines at the bottom to indicate the leaf blades and stem.

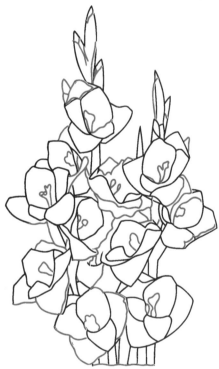

3. Add detail to the flower centers and define the budding leaves at the top. Add some more detail to the outer edges of the petals.

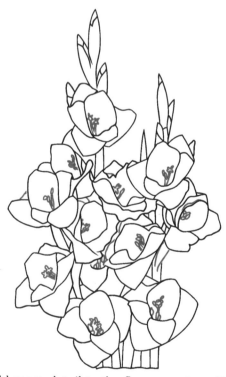

4. Add more detail to the flower centers. Notice the pellet type seeds that make up the center detail. Finish your drawing with some additional shaping of the petals to create a variety of triangular shapes. Refine the bud spikes at the top.

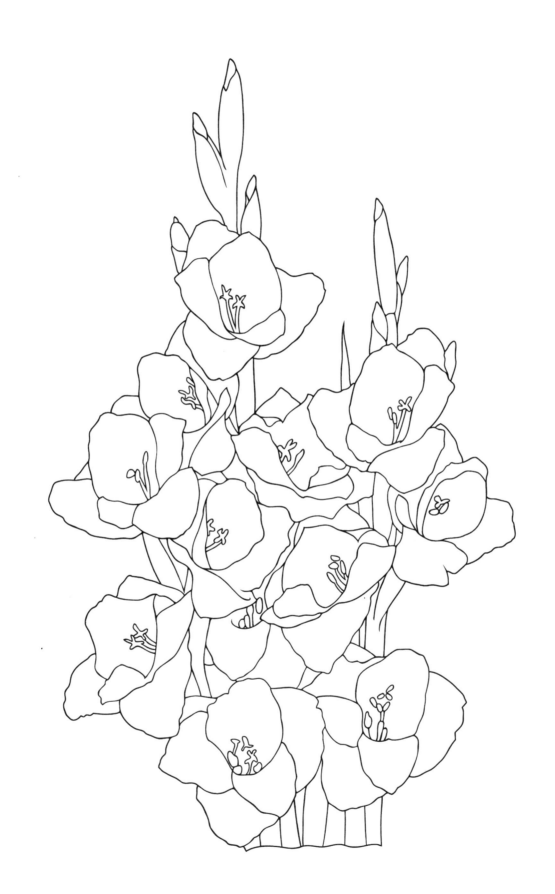

# HIBISCUS

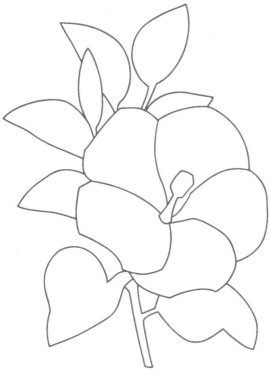

1. Draw in the large, outer shape of the flower with five curved lines for the petals. Add an outline for the filament and style at center. Draw the stem and leaf shapes, and an oval shape for the flower bud.

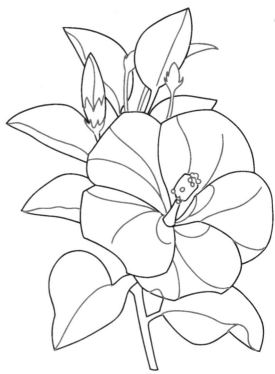

2. Add some detail to the bud showing the separate structures. Add two narrow stems and smaller buds above the flower. Add veins to the leaves, and define the leaf edges. Add definition lines to the petals, and add detail to the center style.

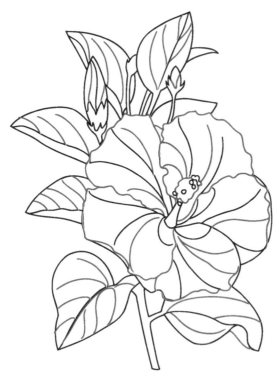

3. Draw some curved veins on the leaves and on the larger bud. Add detail to the smaller bud. Accentuate the ragged edges of the petals.

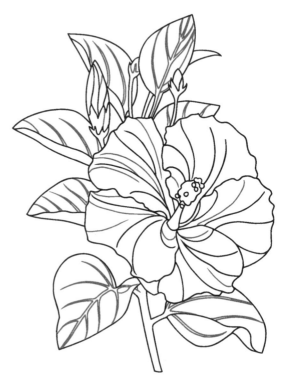

4. Finish the veins on the leaves, and refine the tips. Add more lines to the petals, leading to the center. Finish up by accentuating the edge of the leaves, and defining where the leaves and stem meet, as shown on the next page.

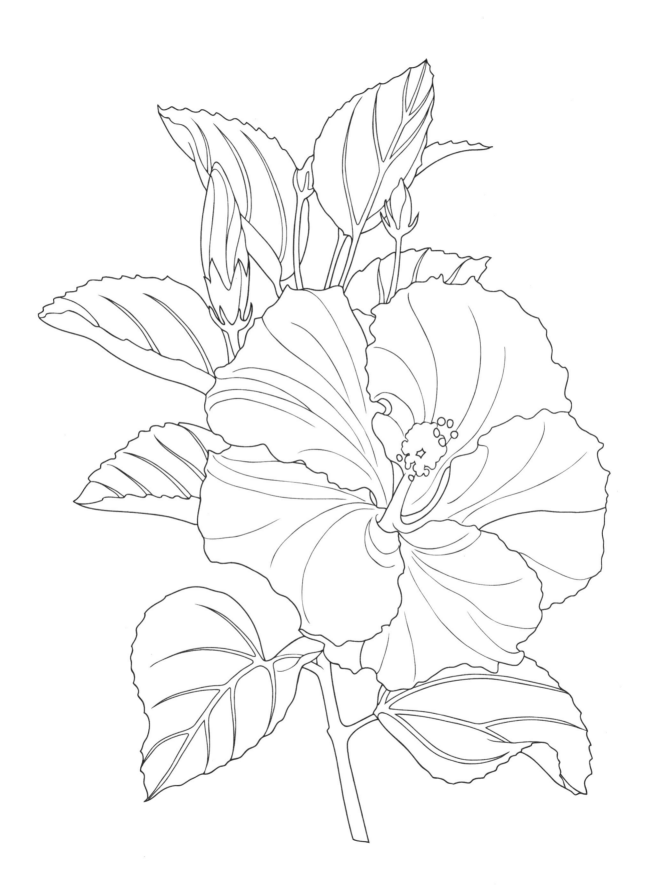

# IRIS

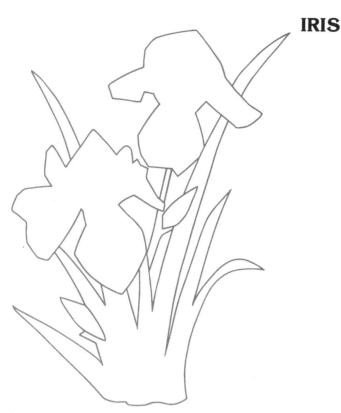

1. Draw a simple outline for the two flowers, the buds, and the leaves. Notice the outward tilt of both flowers.

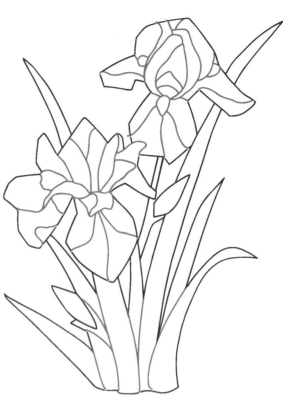

2. Add some lines to roughly define the placement of the petals. This will indicate where petals overlap others and the direction they grow. Add several lines to the leaves to separate the individual spears.

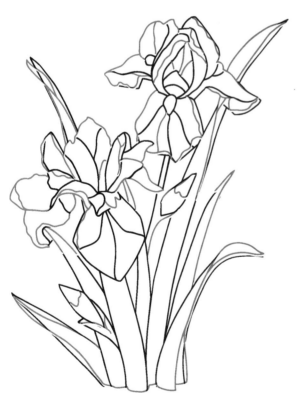

3. Add some lines to the interiors of the flowers, and modify the outer edges with the addition of wavy lines. Add some detail to the buds and refine the shape of the ends of the leaves by adding a few new lines.

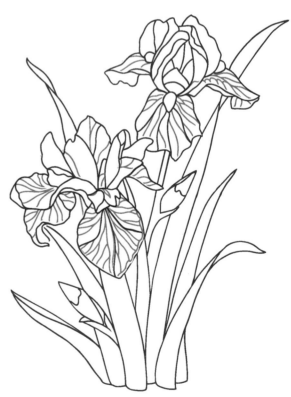

4. The addition of many lines on the lower petals will give the iris some of its distinct characteristics. Add a few lines to the top petals. Finish your drawing with some additional shaping of the petals and details on the buds.

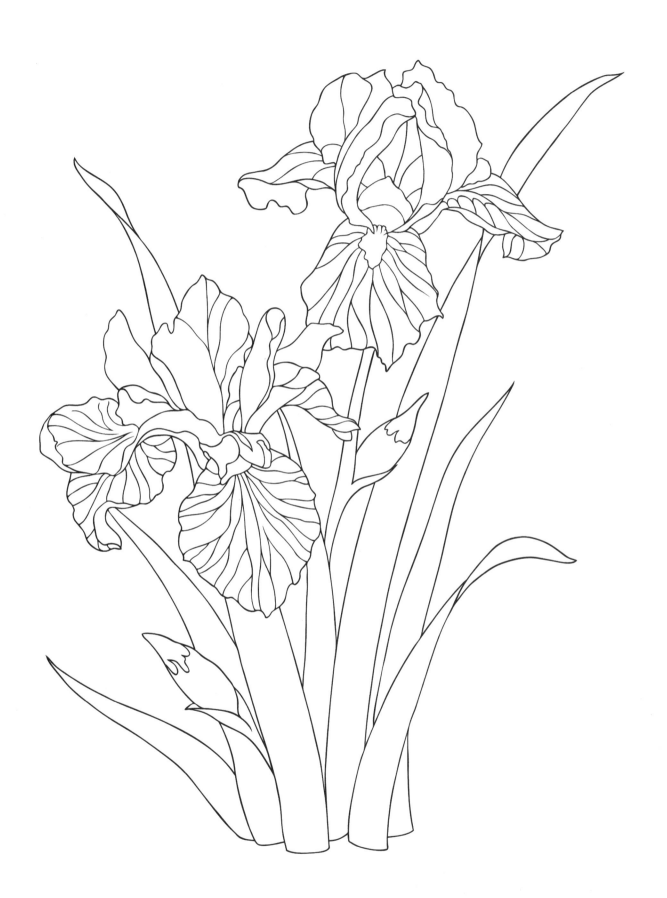

# MORNING GLORY

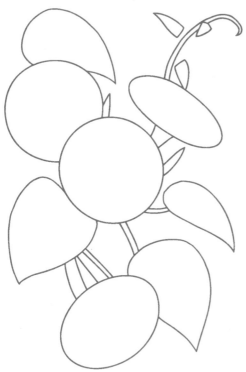

1. Draw two overlapping circles. Draw two slanted ovals, the upper one having a more narrow appearance. Add four tear-shaped leaves and some lines for the stems, some tiny leaves, and two buds peeking out from behind the round shapes.

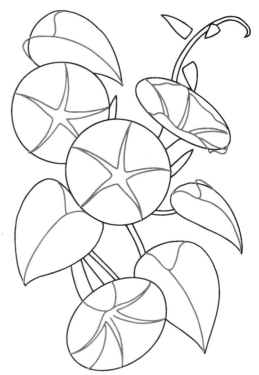

2. Draw a narrow star design inside each flower and add a few curving lines to emphasize its shape. Draw an indentation on the top part of each leaf to give them shape, and add curving lines to each for the center vein.

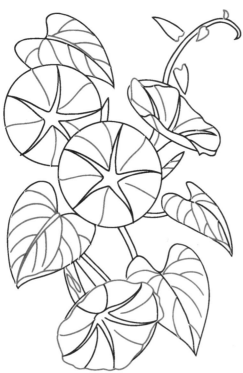

3. Add another tiny leaf to the top stem. Draw curving, secondary veins off the center vein of each leaf. Add curving lines on the flowers between the star shapes, from edge to center. Define the outer edge of the two oval flowers.

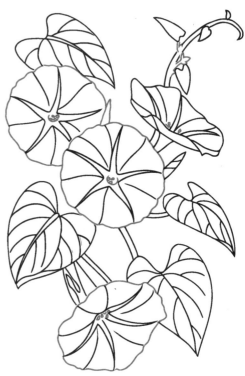

4. Define the outer edge of the two round flowers. Add detail to the centers of all the flowers, and detail to the upper stem where the leaves connect. Finish up by refining the edges of the leaves and flowers.

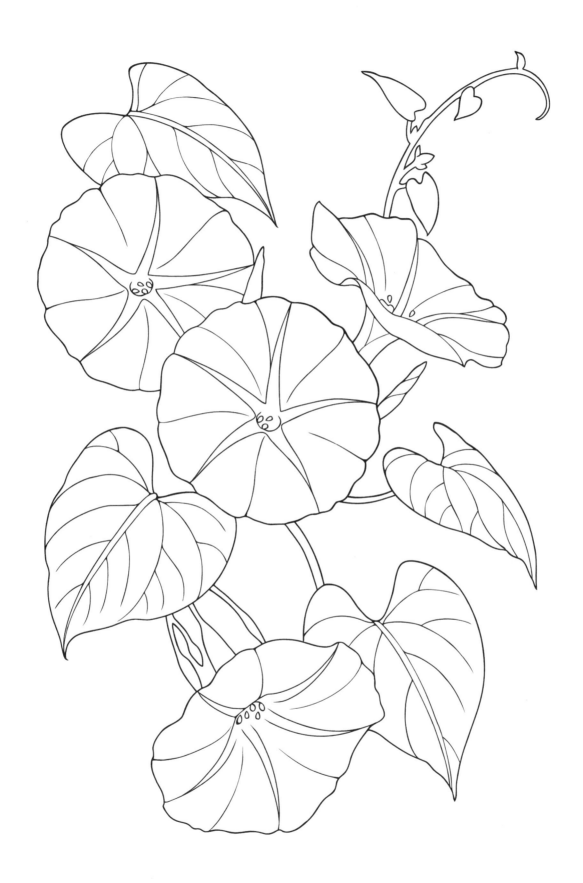

# PANSY

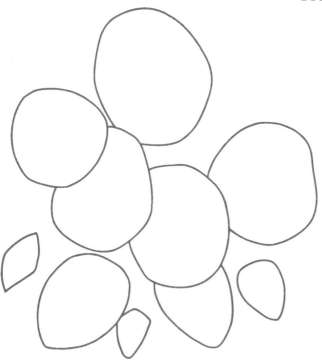

1. Draw five overlapping rounded shapes for flowers and four smaller shapes along the bottom for leaves. Add a fifth small shape on the left for a bud.

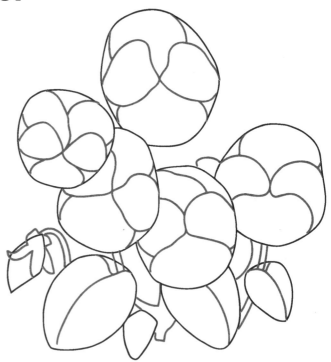

2. Draw the lines for the petals inside each of the five shapes, paying attention to where the petals intersect. Add stems and center lines to the leaves. Draw a leaf cluster on top of the bud.

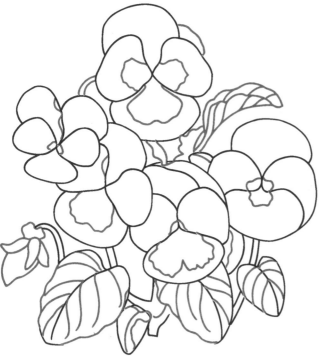

3. Begin adding ragged lines to the petals, to indicate color separation. Add more veins to the leaves, and another leaf in the space between the two upper flowers. Refine the shape of the small center leaf at the bottom.

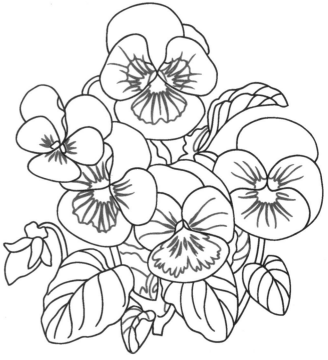

4. Draw the rest of the detail on the flowers. These patterns give the pansy its distinctive coloration. Add some detail to the spaces around the flowers to suggest more leaves. Finish up by refining the veins of the leaves and the detail on the flowers. Define the flower edges with a wavy appearance, as shown on the next page.

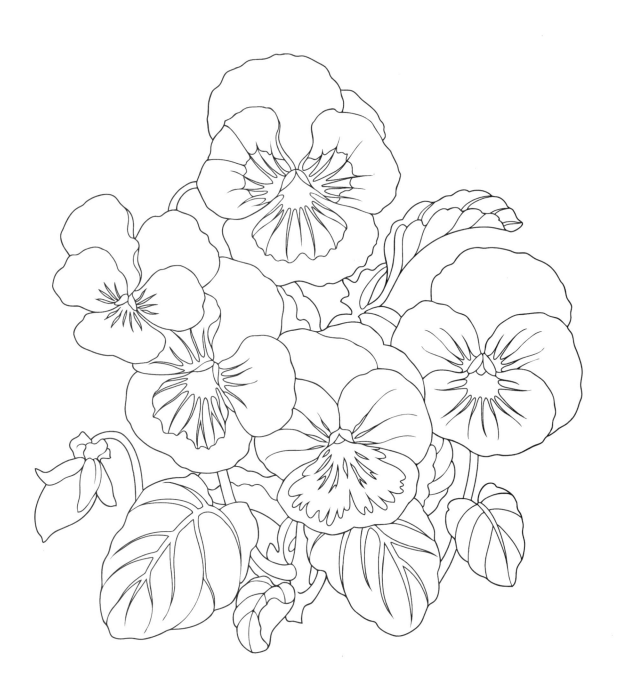

# PEONY

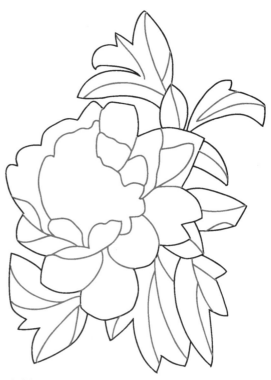

1. Draw the general shape of the flower. It will have an irregular appearance, suggesting that the blossom is at an angle to the viewer. Draw the leaf shapes behind the flower.

2. Add some curving veins to the leaves, and some rounded lines to suggest petals on the flower. (The outer petals will be much larger than those we will add to the center in step 4.)

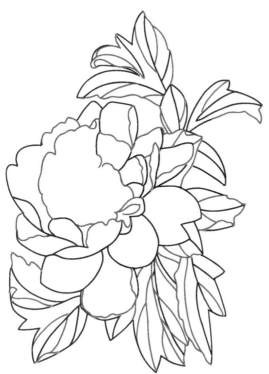

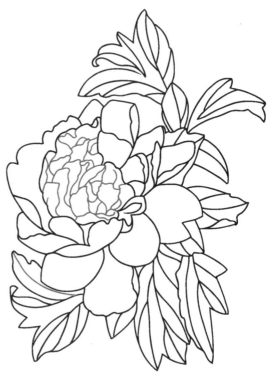

3. Draw some more veins, and define the edges on some of the leaves and flower petals. The leaves have a deeply lobed appearance.

4. Draw the interior flower petals, noting how they curl upward (you are mostly seeing the backs.) Add one more leaf vein on the bottom left. Finish up by defining the outer petal edges with wavy line work and pay attention to how all the petals overlap.

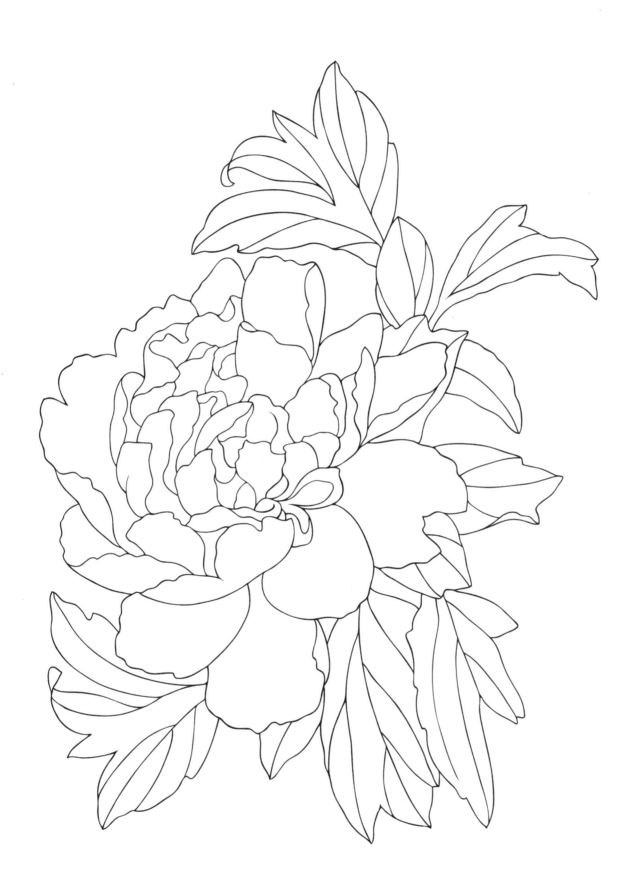

# ROSE

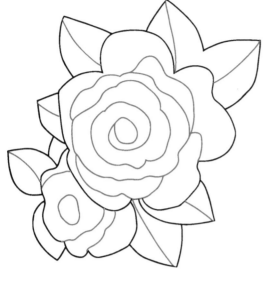

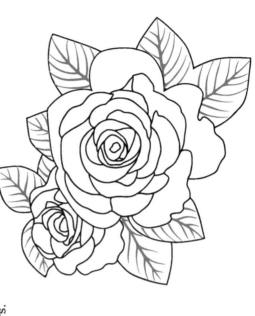

1. Draw two overlapping shapes for the flowers, the one on top being the larger shape. Add some leaf shapes under the flowers.

2. Draw lines down the middle of the leaves for the central veins. Add circular shapes to the flower centers, and a ragged spiral starting from the middle on the larger flower. Add a few more lines to suggest petals on both flowers.

3. Add second line to the center vein of each leaf. Starting at the center of each flower, draw overlapping petals that work their way out along the lines of the spiral.

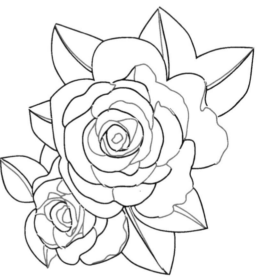

4. Add more veins to the leaves. Add some small petals to the center of the flower. As on some of the other flowers, the inner petals point upright and lay more open as they move out. Finish up by refining the outer edges of the leaves with a ragged line, as shown on the next page.

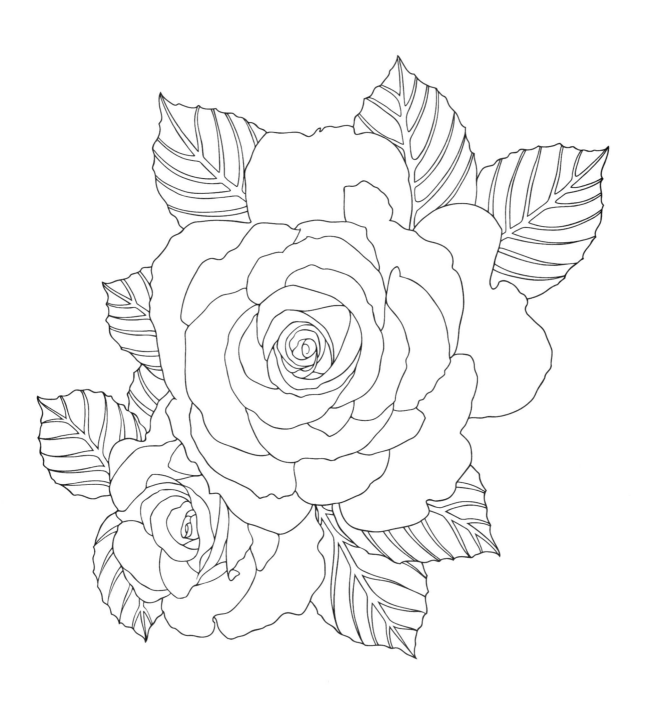

# TULIP

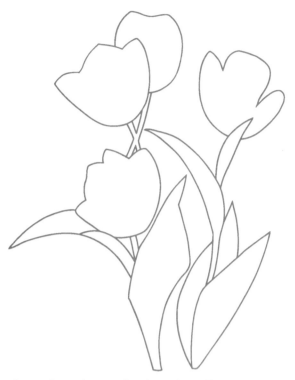

1. Draw four shapes for the tulips. Each one is slightly different in shape, the one in the back left indicating a partially opened flower. Add shapes for the leaves and the stems.

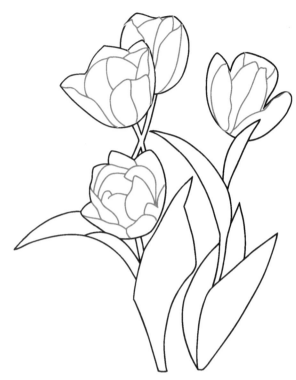

2. Add petal lines to the flowers. Take notice of where they overlap.

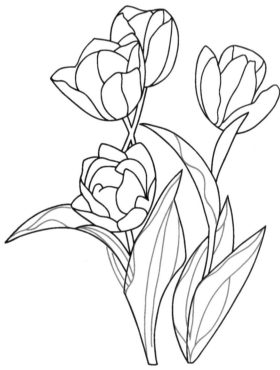

3. Draw a number of lines on the leaves to emphasize their shape. The leaves curve and wrap around the stems, and the edges on some have a wavy appearance.

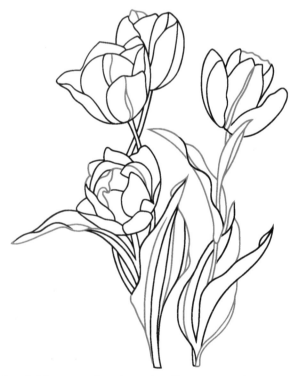

4. Add more detail to the flowers, and more lines to the leaves. Finish up by refining your drawing until you are satisfied with the composition.

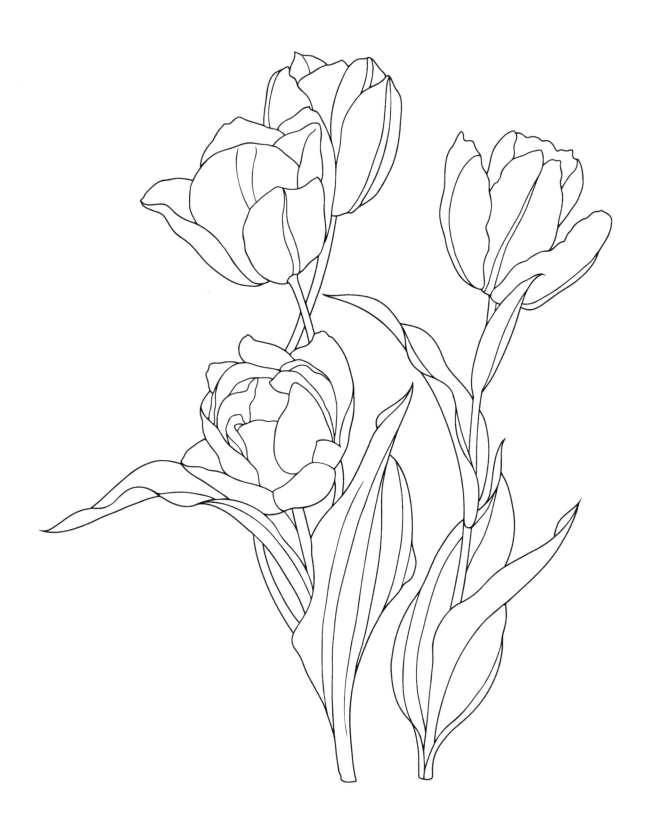